John Baldessari

Lewis Baltz

Richard Barnes

Uta Barth

Ken Botto

Kim Brown

Mark Citret

Brad Cole

Linda Connor

Miles Coolidge

Eileen Cowin

Judy Dater

Luis Delgado Qualtrough

John Divola

Rod Dresser

James Fee

Robbert Flick

Jack Fulton

Maizie Gilbert

Joel Aaron Glassman

Jim Goldberg

Ken Gonzales-Day

Todd Gray

Doug Hall

Deborah Hammond

Kevin Hanley

Tom Hawkins

Anthony Hernandez

Lynn Hershman

Todd Hido

John Humble

Clint Imboden

Michael Kenna

Dale Kistemaker

Robin Lasser

Dinh Q. Le

Michael Lewis

Sharon Lockhart

Laurie Long

Daniel Joseph Martinez

Roger Minick

Richard Misrach

Han Nguyen

Kelly Nipper

Abner Nolan

Catherine Opie

Gay Outlaw

Rondal Partridge

Nigel Poor

J. John Priola

Philipp Scholz Rittermann

Richard Ross

Liza Ryan

Rocky Schenck

Susan Schwartzenberg

Susan Silton

Camille Solyagua

Don Suggs

Larry Sultan

Stephanie Syjuco

Arthur Tress

Catherine Wagner

Henry Wessel

Jo Whaley

Kelli Yon

# beyondboundaries

CONTEMPORARY PHOTOGRAPHY IN CALIFORNIA

Front and back cover:
Liza Ryan, *Displacement 2*,
Detail, 1998, C-print,
4 $^3/_4$ x 11 $^1/_2$ in., Courtesy of
the artist and Griffin
Contemporary, Venice,
California

Frontispiece:
Liza Ryan, *Displacement 13*,
Detail, 1998, C-print,
4 $^3/_4$ x 11 $^1/_2$ in., Courtesy of
the artist and Griffin
Contemporary, Venice,
California

Exhibition Venues

June 20 - August 6, 2000
University Art Museum,
California State University,
Long Beach, California

November 11 - December 24, 2000
Santa Barbara Contemporary
Arts Forum, Santa Barbara,
California

January 9 - April 29, 2001
The Friends of Photography
at the Ansel Adams Center,
San Francisco, California

Deborah Klochko, Director
Nora Kabat, Associate Curator
Jun Ishimuro, Publications
Manager

Publication support provided
by Sharon Bliss, Tracy Evans,
Grace Loh, and Sasha Thompson

Design by Douglas Becker,
San Francisco

©2000 by The Friends of
Photography
All photographs are copy-
righted in the individual
names of the artists.
ISBN 0-933286-73-2

Partial support provided by
Bank of America Foundation.

Printed  in China

The Friends of Photography
at the Ansel Adams Center
655 Mission Street
San Francisco, CA  94105
www.friendsofphotography.org

Acknowledgments    A project of this scope could not have been done without the energy of
many people. Deborah Klochko, Director of The Friends of Photography,
supported the project from start to finish and her questions and
discussion sharpened the exhibition considerably. The tireless and
well-organized Exhibitions staff, Sharon Bliss, Exhibitions Coordinator,
and Sasha Thompson, Exhibitions Assistant, were instrumental through-
out every detail of the project. Rose Fiorentino, Exhibitions Coordinator,
and Stephanie Prussin, Exhibitions Intern, laid critical groundwork during
the exhibition's early stages. Jun Ishimuro, Publications Manager,
oversaw the catalog with care and enthusiasm, and Dan Meinwald, an
ideal editor, made the preparation of the book an intelligent process.
Gratitude also must be extended to the rest of the staff of The Friends of
Photography who managed to work with patience around tables piled
with portfolios. Mary-Kay Lombino, Curator of Exhibitions at University
Art Museum, California State University, Long Beach, became a
committed advocate of the project and a trusted friend, and Meg Linton,
Executive Director, Santa Barbara Contemporary Arts Forum, was a
pleasure to work with in coordinating the travel of the exhibition to the
Central Coast. Finally, a sincere thank you to all of the perceptive
photographers of California, represented here or not, with whom we had
the good fortune to engage in discussion, and the following important
members of the photography community who took the time to share their
expertise in the field:

ACME.
Gallery Paule Anglim
Black Gallery
Rena Bransten Gallery
California College of Arts and Crafts
California State University at Long Beach,
    University Art Museum
Center for Photographic Art
Mary Ceruti
Catharine Clark Gallery
Stephen Cohen Gallery
Fahey/Klein Gallery
Patricia Faure Gallery
Fraenkel Gallery
Gallery of Contemporary Photography
Haines Gallery
Headlands Center for the Arts
Debra Heimerdinger Fine Arts Photography
Glen Helfand
Hosfelt Gallery
Intersection for the Arts
Jan Kesner Gallery
Robert Koch Gallery
Paul Kopeikin Gallery
Craig Krull Gallery
Los Angeles Center for Photographic Studies
Los Angeles Contemporary Exhibitions
Los Angeles County Museum of Art
Los Angeles Municipal Art Gallery
    at Barnsdall Park
The Mexican Museum

Thomas V. Meyer Fine Art
Jeanne Meyers
Mills College Art Gallery
The Museum of Contemporary Art, Los Angeles
Museum of Contemporary Art, San Diego
Museum of Photographic Arts
Nazraeli Press
PacoWildensteinMacGill
PhotoMetro
Photos Gallery
Marla Porges
San Francisco Art Institute
San Francisco Camerawork
San Francisco Museum of Modern Art
San Jose Museum of Art
Santa Barbara Contemporary Arts Forum
Shapiro Gallery
Rebecca Solnit
Southern Exposure
Susan Spiritus Gallery
Patricia Sweetow Gallery
Meredith Tromble
UCR/California Museum of Photography
University of California, Berkeley Art Museum
    and Pacific Film Archive
Weston Gallery
Stephen Wirtz Gallery
Linda Wolcott-Moore
Works on Paper
Yerba Buena Center for the Arts

# "We can find only bits and pieces of clues. And this small portfolio is just the crudest sketches of what it's all about."

Duane Michals, quoted in Susan Sontag, *On Photography*

**Essay**  This project began with an innocent question, casually asked—what is the most compelling photography made in California in the last five years? *Beyond Boundaries: Contemporary Photography in California* is one answer to that question.

Initially, the project was to be small, limited to only five or six photographers. Certain artists came readily to mind, but what of those whose names escaped us? We arrived at a systematic approach whereby over seventy photography experts in the state–museum curators, gallery directors, art publishers and critics, specialists in the small non-profit organizations and the large metropolitan museums—were asked to list the four photographers they felt were making the most compelling work. The response was tremendous. Portfolio requests were mailed out, and packages of slides were mailed in. Studio visits were scheduled with more than half of the two hundred thirty-two nominees. As the exhibition increased in size, it developed into a collaboration between The Friends of Photography and the artists. During each studio visit there was a discussion about which pieces most clearly represented

the artist, and about how their work could be successfully and succinctly conveyed in a large group show. The high quality of work being created in California was sharply evident - these artists were wrestling with critical issues which placed them squarely in the international arena.

An evaluation of contemporary art is a difficult and imperative task, challenging because we do not have the advantage of historical distance and critical because of art's role as a mirror of our collective experience. A contemporary exhibition of this kind provides a visual layering of loose connections and affiliations—categorizations without titles, comparisons which lead to oblique answers -a shifting paradigm of what is happening out there. *Beyond Boundaries* juxtaposes one image to the next, cutting across generational, gender, and racial specificities. It is arranged as a loosely thematic collage which echos the criss-crossing threads of the sixty-five artists in the exhibition. The result is non-linear, a fragmented conversation occurring between the picture frames, each piece an answer leading to more questions. Slowly a dialog reveals itself.

What emerges are the rubbish and remnants, traces and confessions of modern life. Whether in the discarded American flag gathered on Nigel Poor's daily walk or the luminescent specimen jars of Camille Solyagua, in the meticulously preserved childhood train tracks of Dale Kistemaker or the symbolic electric chairs of Luis Delgado Qualtrough, in the still, mute moments of Eileen Cowin or the spare, hollow bedrooms of Sharon Lockhart, in John Divola's search for transcendence in the strip malls of Los Angeles or in Larry Sultan's filmic images of the pornography industry, the artists in this exhibition attempt a delicate balance between compassion and critical distance. The photographers are, in one sense, mindful yet wary of art's traditional role of conveying elemental truths. At the same time, they remain painfully aware of the modern world's unceasing construction of simultaneous meanings.

The inherent limitations of curatorial choice allowed for only a very small representation of the enormous amount of talent within California. My hope is that the decisions made during the organizing of this exhibition will spark a dialog beyond the walls of the museum, into the studios where so much dynamic work is being created.

Nora Kabat
Curator of the Exhibition

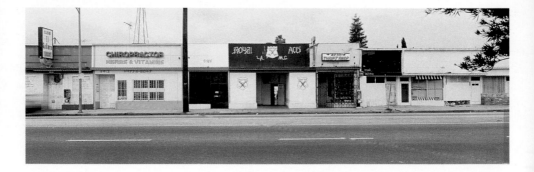

*PLATE* 2 | **ROBBERT FLICK**

*LONG BEACH HARBOR*

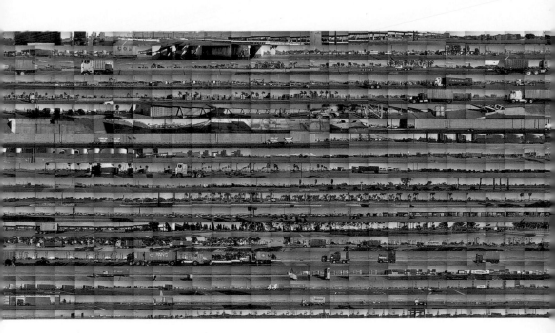

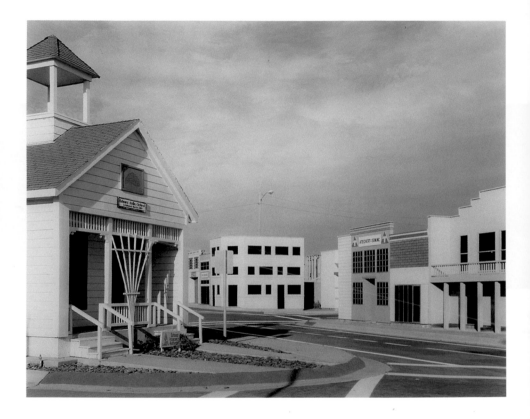

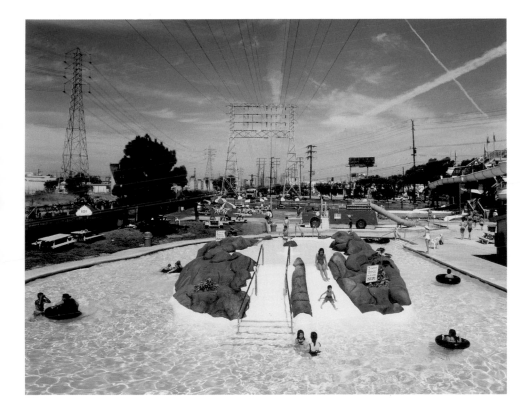

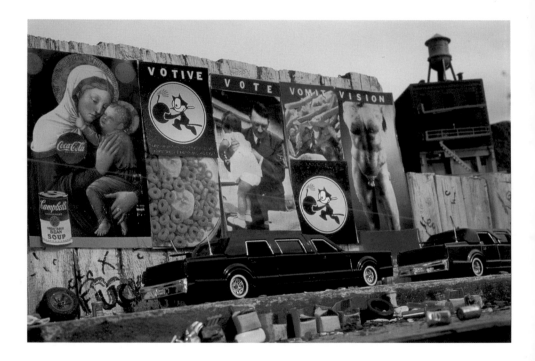

*PLATE* 6 | ROGER MINICK

*FACE OF CRAZY HORSE, 1999*

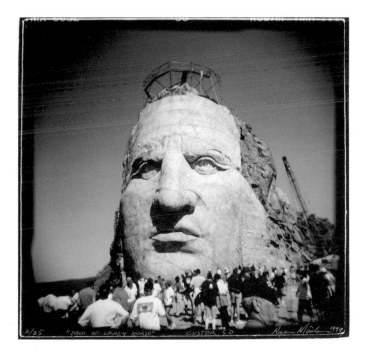

RICHARD MISRACH | *PLATE 7*

*SWAMP AND PIPELINE, GEISMAR, LOUISIANA*

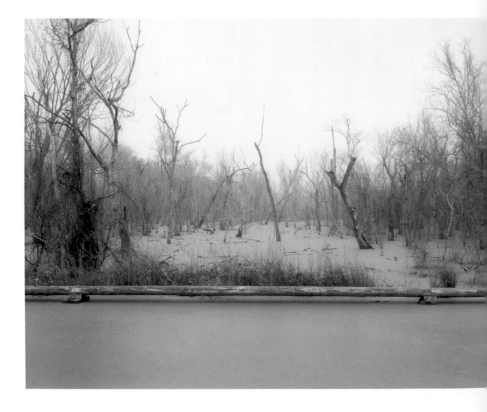

*PLATE* 8 | PHILIPP SCHOLZ RITTERMANN

*HOOVER DAM*

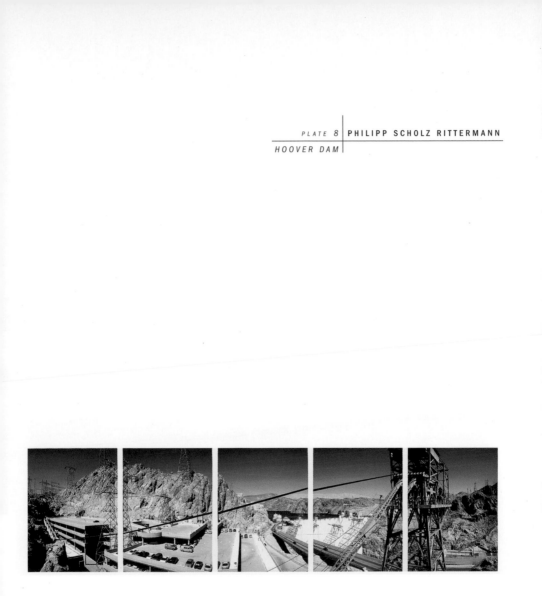

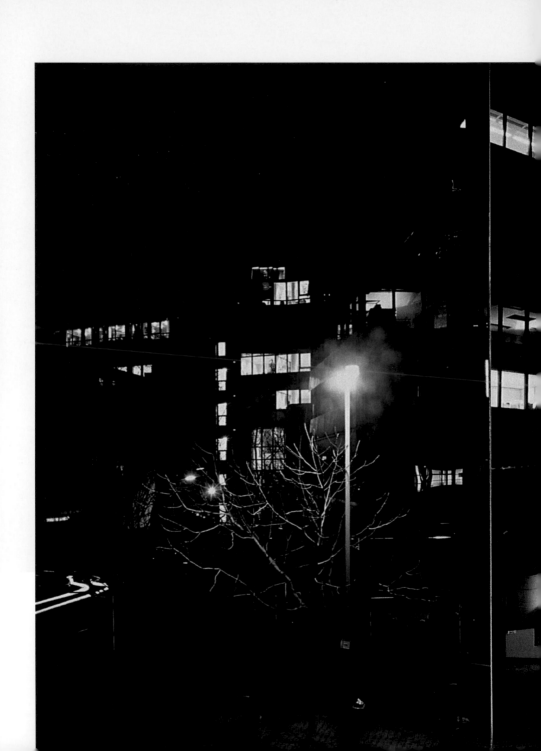

*PLATE* 9 | LEWIS BALTZ
*BETTINASTRASSE*

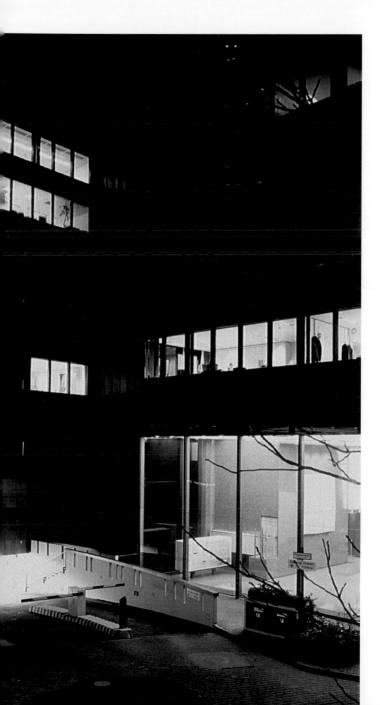

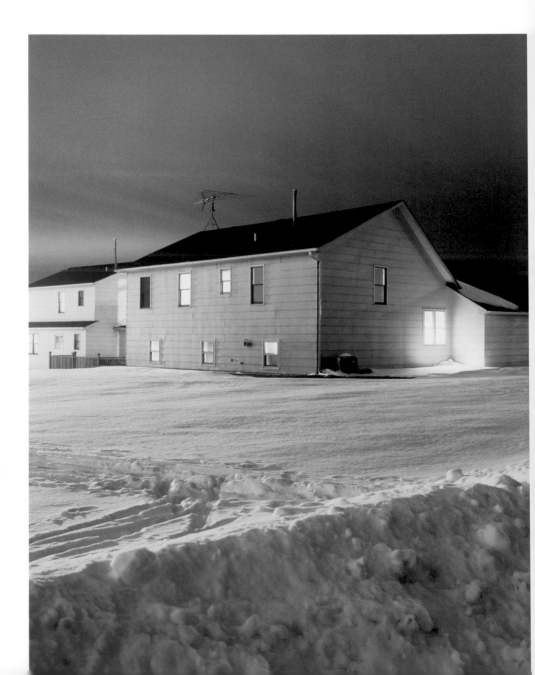

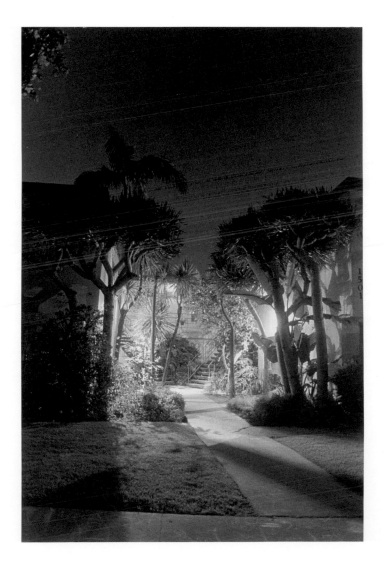

PLATE *11* | HENRY WESSEL

*LOS ANGELES NO. 23*

**DOUG HALL** | *PLATE 12*

*VATICAN LIBRARY, MAIN READING ROOM*

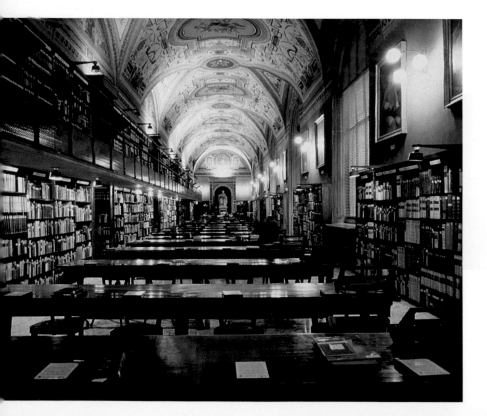

*PLATE* *13* | **RICHARD ROSS**

*TALLY PAGODA, BAGAN, MYANMAR*

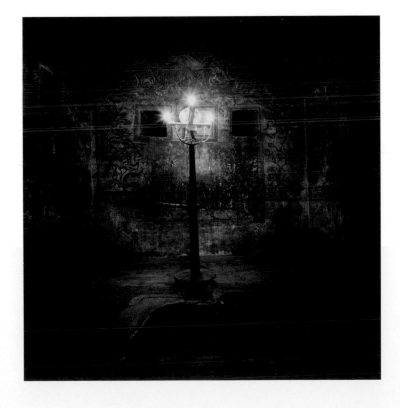

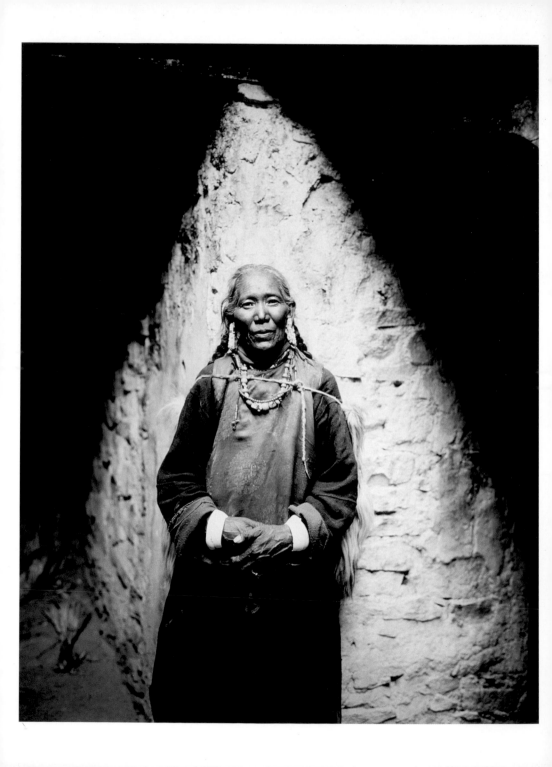

*PLATE* 15 | **BRAD COLE**
*REMNANTS* 8

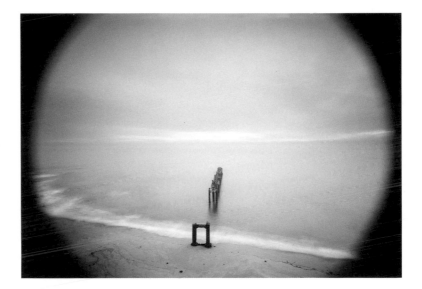

PLATE *17* | **TOM HAWKINS**
*OBELISK AT SALT PANS: BONAIRE*

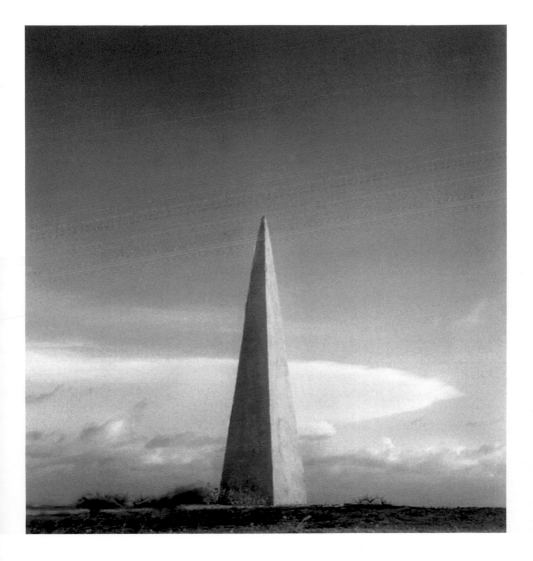

*PLATE* 19 | **KEVIN HANLEY**
*UNTITLED* |

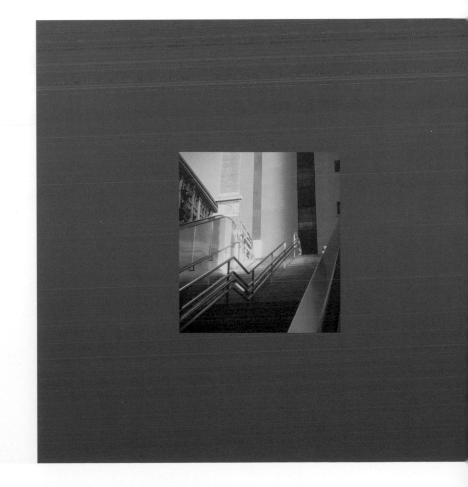

*PLATE* 20 | **RICHARD BARNES**

*UNABOMBER CABIN (EXHIBIT D)*

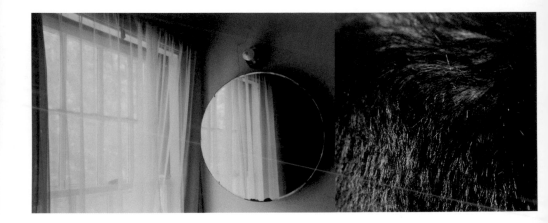

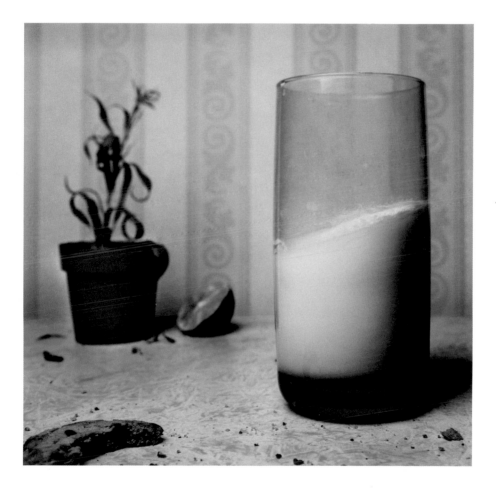

PLATE 22 | MICHAEL LEWIS
UNTITLED

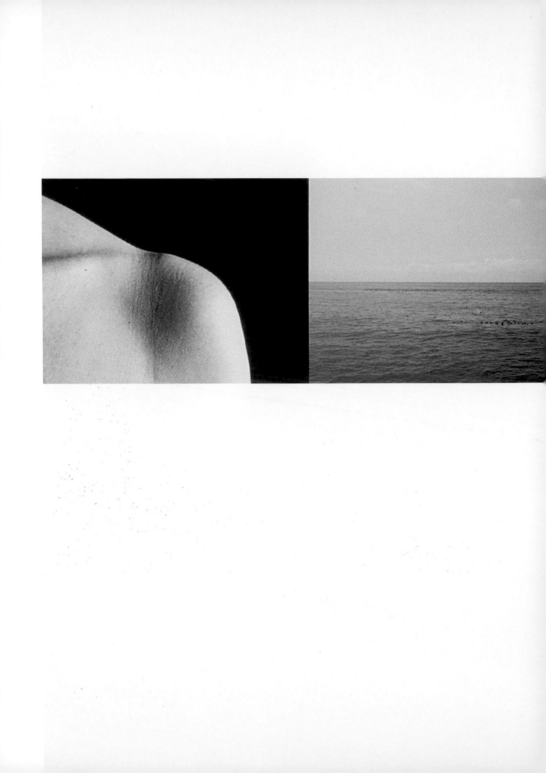

PLATE *23* | **EILEEN COWIN**

*RETURNING TO ORDINARY LIFE*

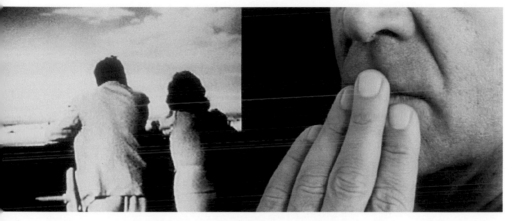

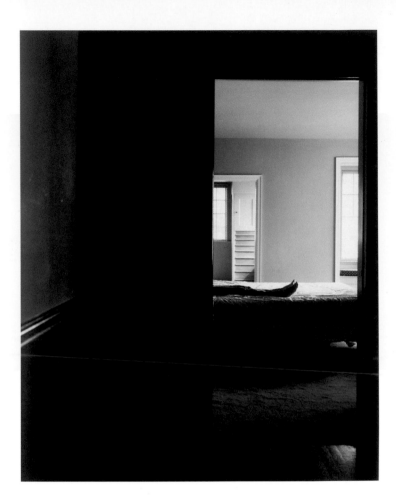

SHARON LOCKHART | PLATE 24
| UNTITLED

*PLATE 25* | **KELLY NIPPER**
*MOVEMENT WITH CHALK*

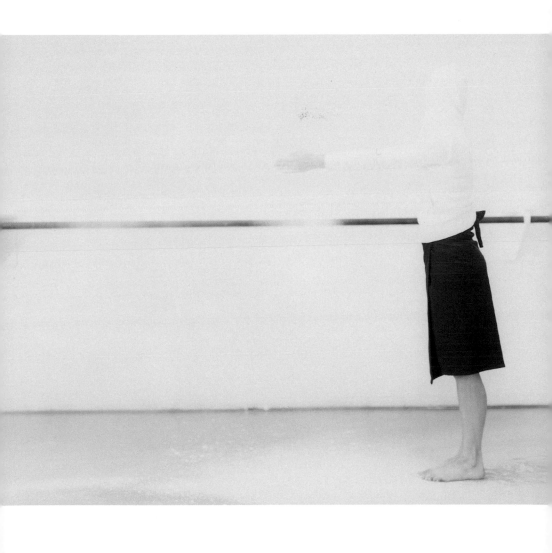

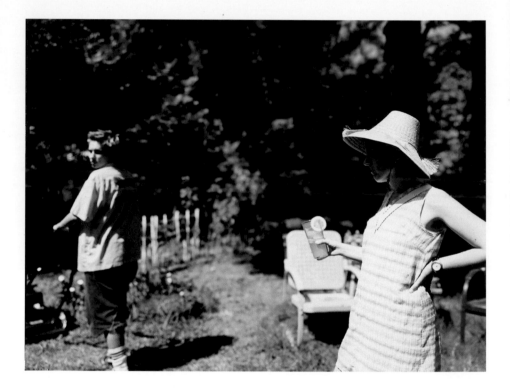

CATHERINE OPIE | *PLATE 26*

*TAMMY RAE & KAIA, DURHAM, NORTH CAROLINA*

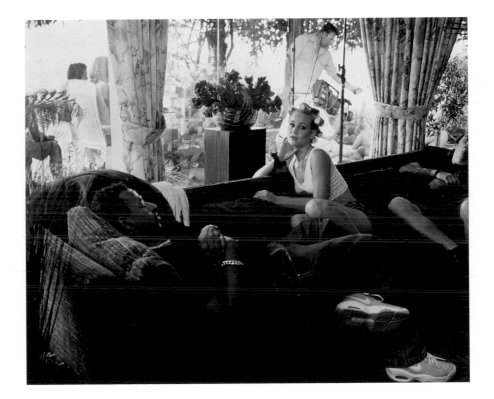

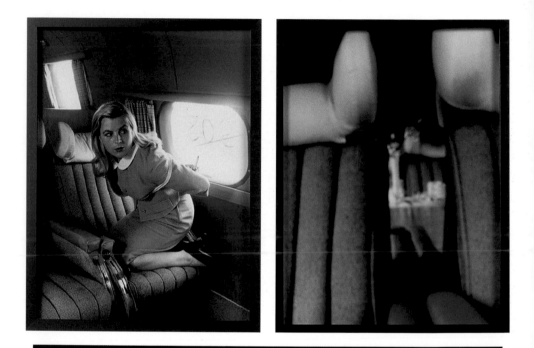

*Nancy wrote a large SOS backwards on the pane*

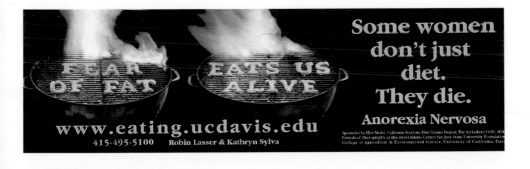

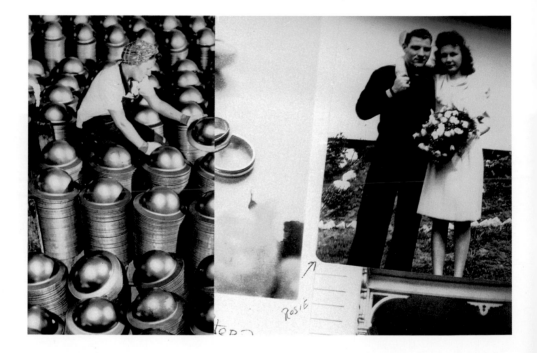

PLATE *31* | **ARTHUR TRESS**

*GETTING HOOKED, ACT 3*

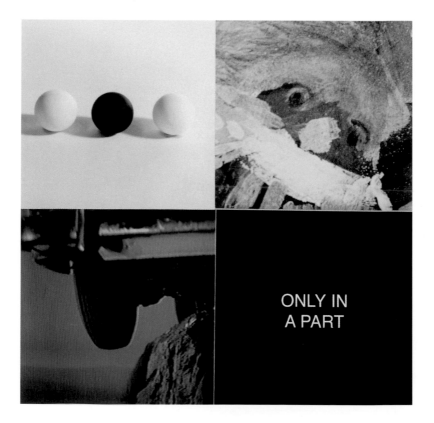

*PLATE* *33* | **JUDY DATER**

*AMORE A PRIMA VISTA*

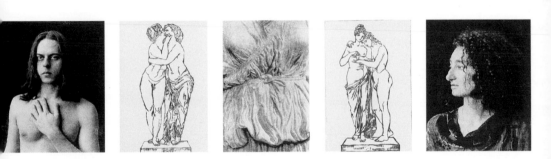

DON SUGGS | PLATE 34
| PACIFIER VII

*PLATE* 35 | **JACK FULTON**

*SMOKIN' WITH THE DEVIL*

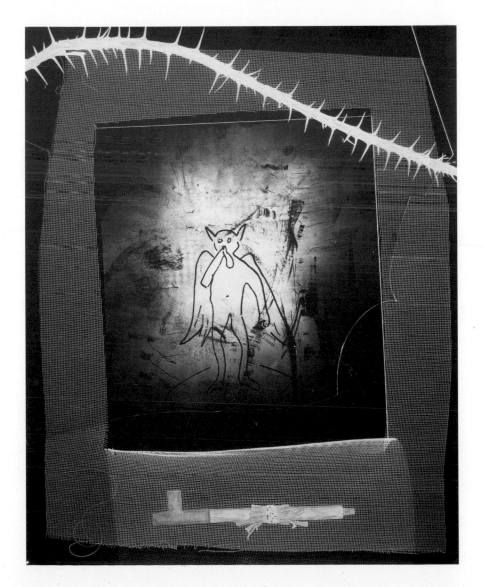

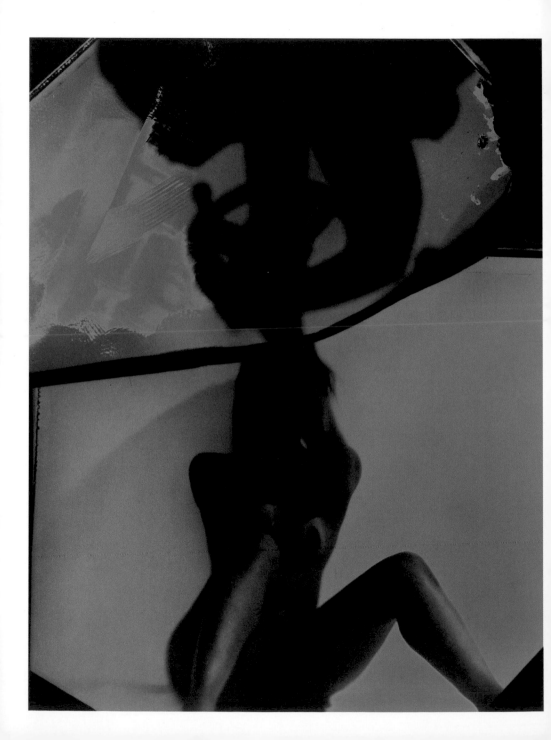

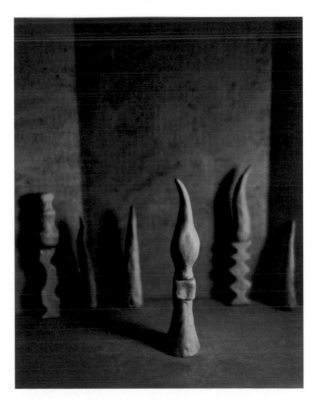

*PLATE 37* | HAN NGUYEN
*BRANCUSI'S BIRD*

ANTHONY HERNANDEZ | *PLATE 38*

*WAITING IN LINE #3*

PLATE 39 | SUSAN SILTON
FIG. 6

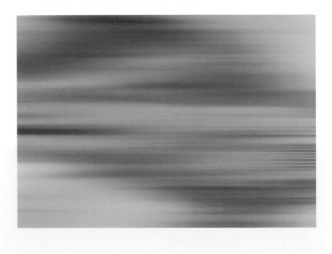

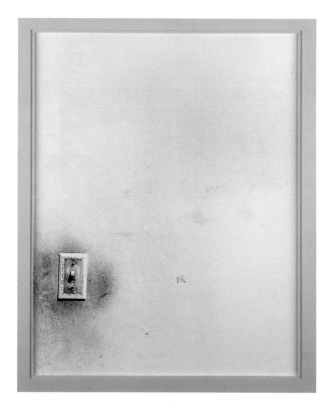

PLATE *41* | **MAIZIE GILBERT**

*UNTITLED #45*

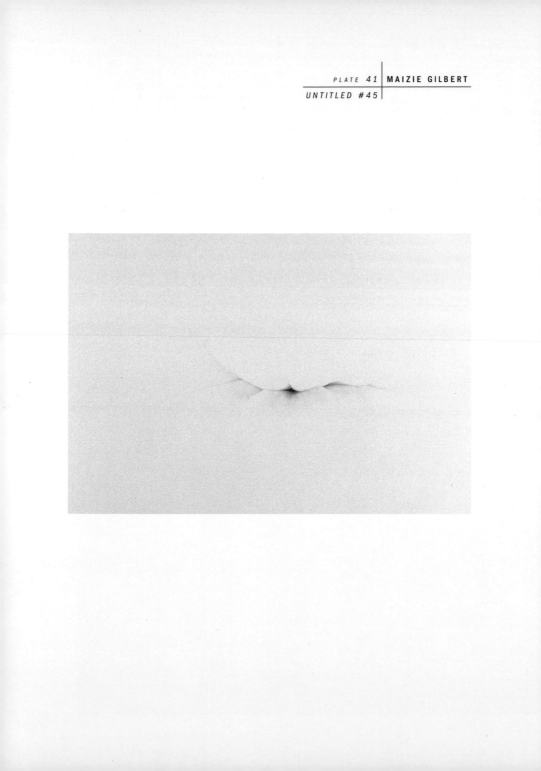

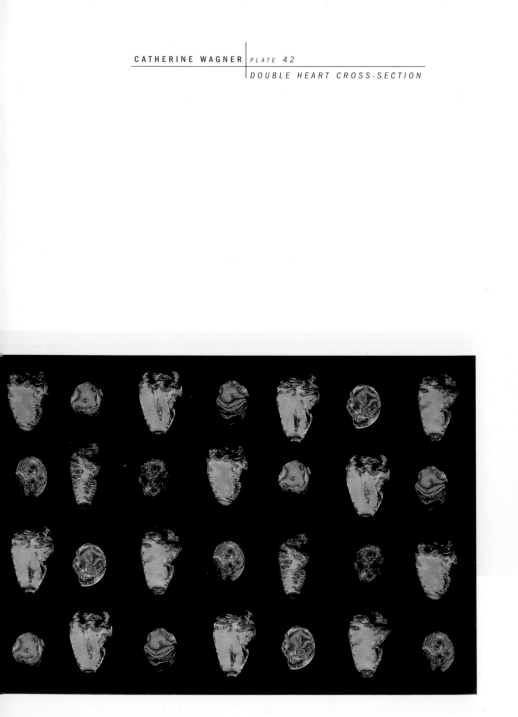

*PLATE* 43 | **ROD DRESSER**

*POWER TOWER, ASSEMBLAGE,*
*DEATH VALLEY NATIONAL MONUMENT, CALIFORNIA, 1996*

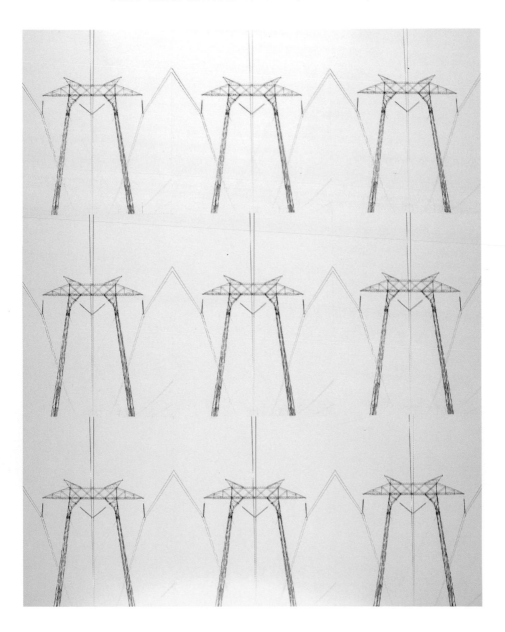

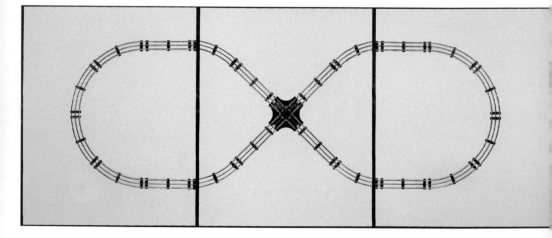

DALE KISTEMAKER | *PLATE 44*
| *TRACK #2*

*PLATE 45* | **GAY OUTLAW**
*LIGHT FIXTURE #3 - "ECLIPSE"*

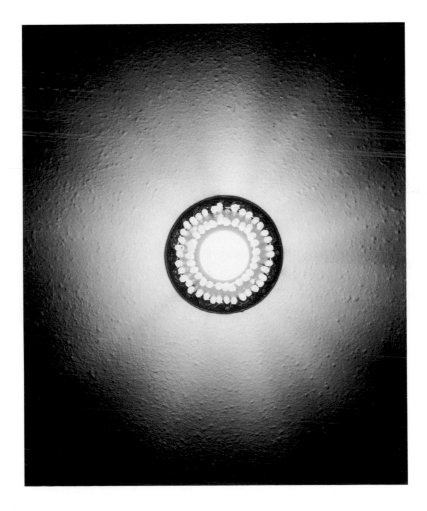

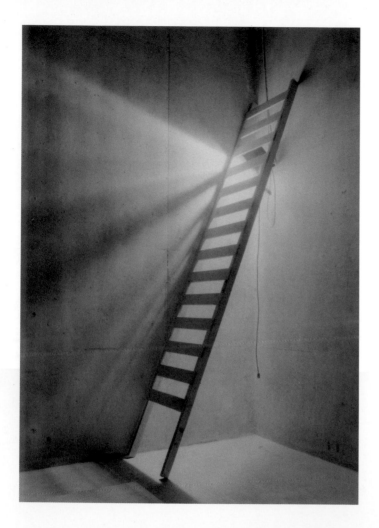

MARK CITRET | PLATE 46
GANG LADDER

*PLATE* 47 | RONDAL PARTRIDGE
*PRESTON PATENT, 1997*

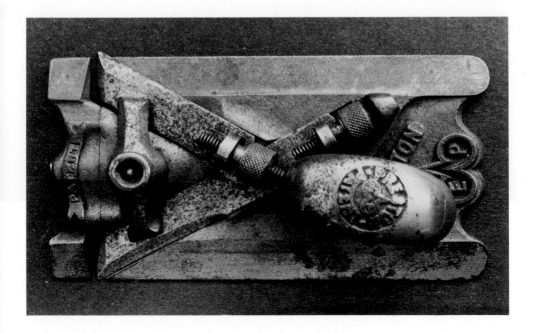

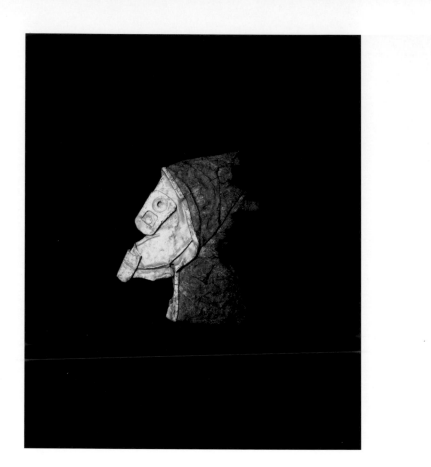

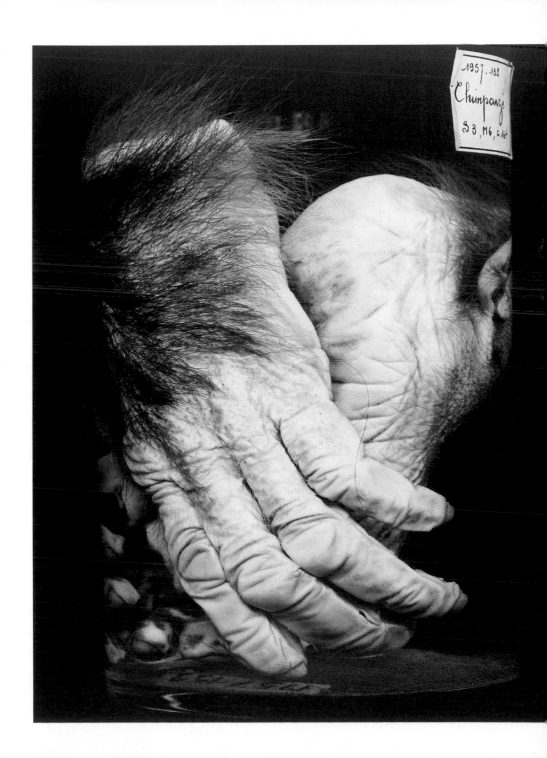

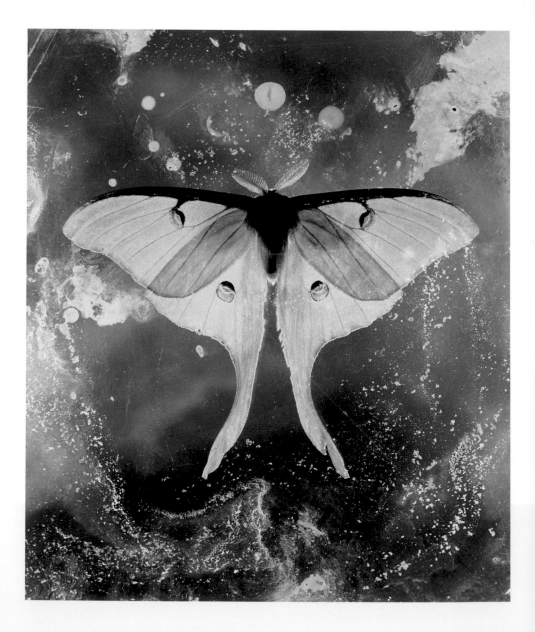

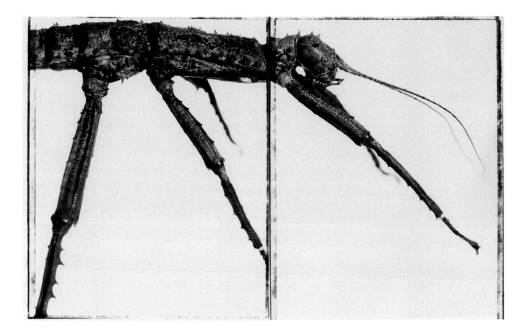

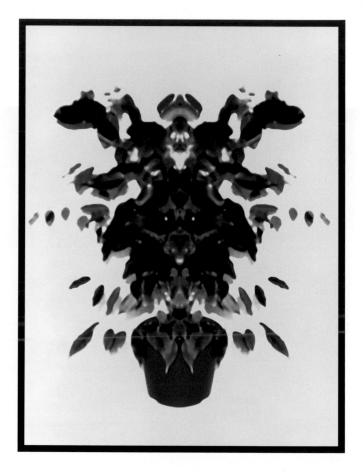

*PLATE* 53 | **LYNN HERSHMAN**
*IDENTITY CYBORG*

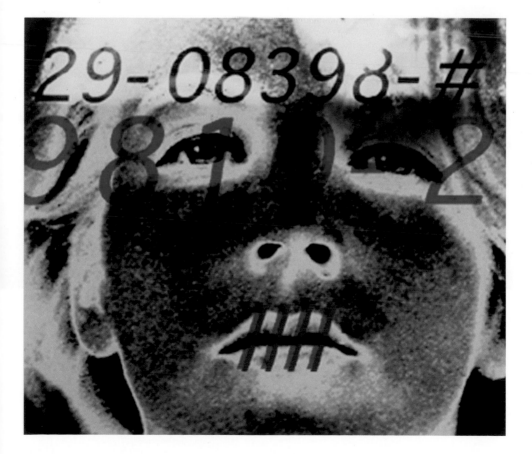

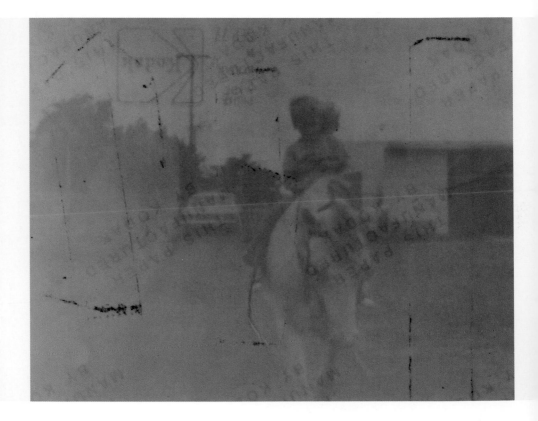

*PLATE* 55 | **DINH Q. LE**

*UNTITLED #15 (CAMBODIA: SPLENDOUR AND DARKNESS)*

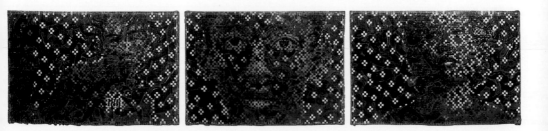

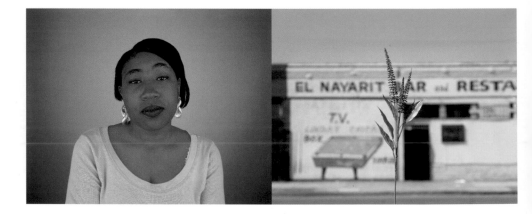

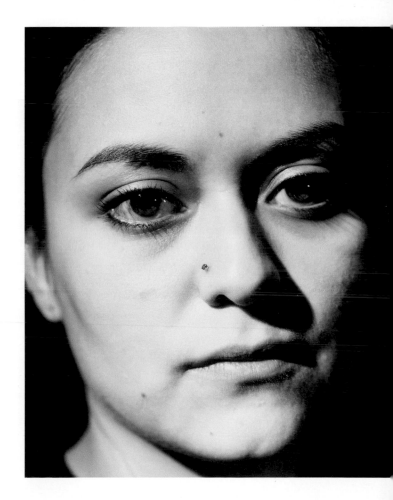

*PLATE 57* | **DEBORAH HAMMOND**
*REGRET III*

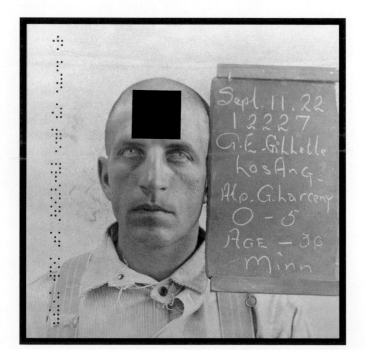

*PLATE 59* | KEN GONZALES-DAY

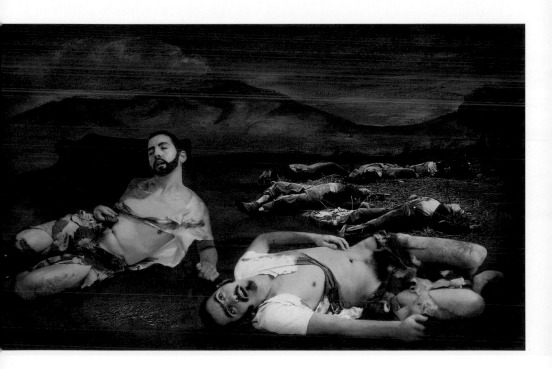

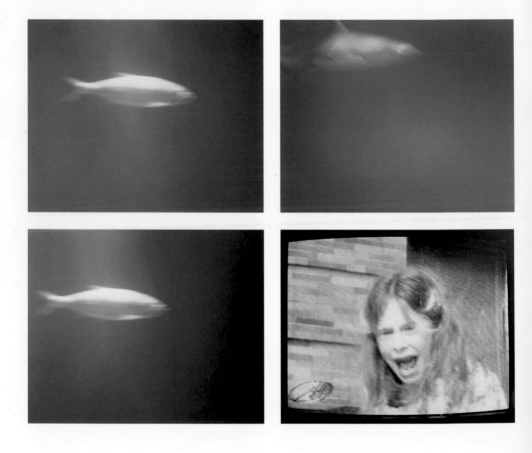

PLATE *61* | **KIM BROWN**
*UNTITLED #4*

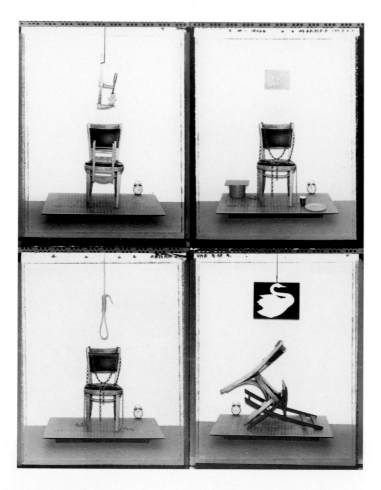

PLATE 63 | JIM GOLDBERG

UNTITLED (DAD'S LAST SHAVE)

PLATE 65 | **TODD GRAY**

*UNTITLED (BOY WITH DUNCE CAP)*

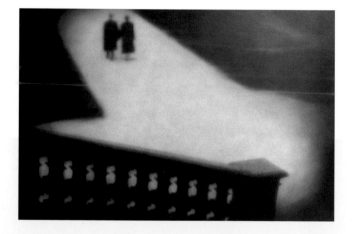

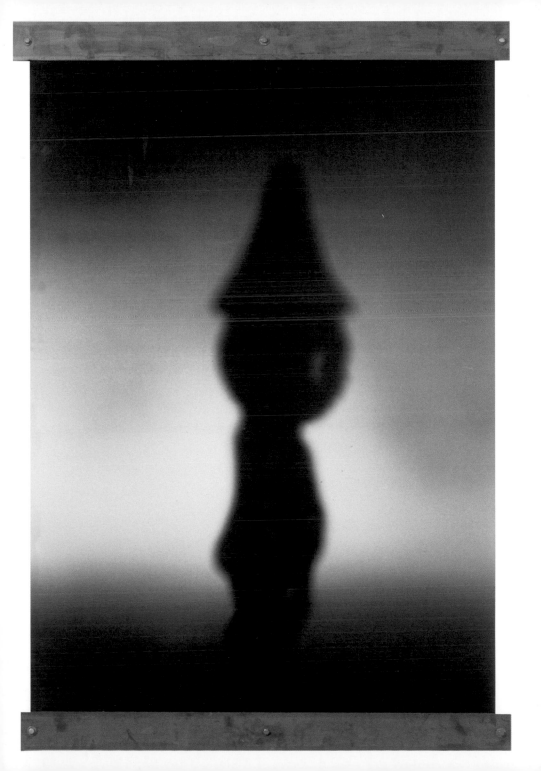

In compiling these biographies, each artist was asked to select one of their recent accomplishments to give a sense of the present state of their career. Some photographers chose to focus on an upcoming exhibition, current project, or monograph, while others decided to share details about their involvement with academic or art institutions.

**JOHN BALDESSARI**, PLATE 32
*Tetrad Series: Only in a Part*, 1998,
Inkjet prints on paper, 22 x 16 $^1/_2$ in.,
Courtesy of the artist and Marian
Goodman Gallery, New York
　　Born: National City, California, 1931
　　Resides: Santa Monica, California
　　Highest Degree: M.A., San Diego State
　　College, California, 1957
　　Monograph: *John Baldessari: While
　　Something is Happening Here,
　　Something Else is Happening There*,
　　Sprengel Museum, Germany

**LEWIS BALTZ**, PLATE 9
*Bettinastrasse*, 1996, Fuji crystal print,
27 x 54 in. total, Courtesy of the artist
and Stephen Wirtz Gallery, San Francisco
　　Born: Newport Beach, California, 1945
　　Resides: Sausalito, California
　　Highest Degree: M.F.A., Claremont
　　Graduate School, California
　　Solo Exhibition: *Lewis Baltz: The
　　Politics of Bacteria, Docile Bodies,
　　Ronde de Nuit*, Museum of
　　Contemporary Art, Los Angeles,
　　California, 1998

**RICHARD BARNES**, PLATE 20
*Unabomber Cabin (Exhibit D)*, 1998,
Gelatin silver print, 52 x 40 in., Courtesy
of the artist and Hosfelt Gallery,
San Francisco
　　Born: Newark, New Jersey, 1953
　　Resides: San Francisco, California
　　Highest Degree: B.A., Journalism,
　　University of California, Berkeley, 1979
　　Award: Eisenstaedt Award
　　in Photography, Columbia University,
　　New York, New York, 1999

**UTA BARTH**, PLATE 18
*Untitled (98.1)*, 1998, Color photographs,
41 x 105 $^1/_2$ in. total, Courtesy of
Rena Bransten
　　Born: Germany
　　Resides: Santa Monica, California
　　Highest Degree: M.F.A., Studio Art,
　　University of California, Los Angeles, 1985
　　Position: Assistant Professor, Art,
　　University of California, Riverside

**KEN BOTTO**, PLATE 5
*The V-Word*, 1990, C-print, 25 $^1/_4$ x 38 in.,
Courtesy of the artist and Robert Koch
Gallery, San Francisco
　　Born: Stockton, California, 1937
　　Resides: Bolinas, California
　　Highest Degree: M.F.A., Claremont
　　Graduate College, California, 1962

**KIM BROWN**, PLATE 61
*Untitled #4* from the series *everything
turns into something else and slips away*,
1999, C-print mounted on aluminum,
40 x 30 in., Courtesy of the artist and
Patricia Sweetow Gallery, San Francisco
　　Born: Greenbrae, California, 1971
　　Resides: Oakland, California
　　Highest Degree: M.F.A., Mills College,
　　Oakland, California, 1997
　　Award: James D. Phelan Art Award in
　　Photography, San Francisco
　　Foundation/San Francisco
　　Camerawork, California, 1997

**MARK CITRET**, PLATE 46
*Gang Ladder*, 1992,
Gelatin silver vellum print, 8 $^3/_4$ x 5 $^3/_4$ in.,
Courtesy of the artist
　　Born: Buffalo, New York, 1949
　　Resides: Daly City, California
　　Highest Degree: M.A., San Francisco
　　State University, California, 1979
　　Monograph: *Along the Way*, Custom &
　　Limited Editions, 1999

**BRAD COLE**, PLATE 15
*Remnants 8*, 1988-99, Toned gelatin
silver print, 16 x 20 in., Courtesy of
Kathleen and Austin Barrows
　　Born: Los Angeles, California, 1957
　　Resides: Carmel, California
　　Monograph: *The Last Dream*, Center for
　　Photographic Art, Carmel,
　　California, 1998

**LINDA CONNOR**, PLATE 14
*Pilgrim, Hemis Monastery, Ladakh, India,*
*Detail*, 1998, Printing out paper,
12 x 10 in., Courtesy of the artist
 Born: New York, New York, 1944
 Resides: San Anselmo, California
 Highest Degree: M.A., Photography,
 Institute of Design, Illinois Institute of
 Technology, Chicago, 1969
 Monograph: *On the Music of the*
 *Spheres*, The Whitney Museum of
 American Art, New York,
 New York, 1996

**MILES COOLIDGE**, PLATE 3
*Schoolhouse, Office Buildings,*
*Storefronts* from the series *Safetyville,*
1994, C-print, 30 x 37 in., Courtesy of the
artist and ACME., Los Angeles and Casey
Kaplan, New York
 Born: Montreal, Quebec, Canada, 1963
 Resides: Los Angeles, California
 Highest Degree: M.F.A., California
 Institute of the Arts, Valencia, 1992
 Position: Instructor, Photography,
 California Institute of the Arts, Valencia

**EILEEN COWIN**, PLATE 23
*Returning to Ordinary Life*, 1997,
Ektacolor prints, 30 x 160 in. total,
Courtesy of the artist
 Born: Brooklyn, New York, 1947
 Resides: Santa Monica, California
 Highest Degree: M.S., Photography,
 Illinois Institute of Technology, Chicago
 Position: Professor of Art, California
 State University, Fullerton

**JUDY DATER**, PLATE 33
*Amore a Prima Vista*,1999, Photo etching
and dry point on Lana Aquarelle,
21 x 56 in. total, Courtesy of the artist
and Smith Andersen Editions, Palo Alto
 Born: Hollywood, California, 1941
 Resides: Berkeley, California
 Highest Degree: M.A., San Francisco
 State University, California, 1966
 Monograph: *Cycles*, 1994

**LUIS DELGADO QUALTROUGH**, PLATE 62
*Capital Crimes*, 1998, Toned gelatin silver
print, 17 x 21 $^3/_4$ in., Courtesy of the artist
 Born: Mexico City, Mexico, 1951
 Resides: San Francisco, California
 Highest Degree: B.F.A., University of the
 Americas, Cholula Puebla, Mexico, 1976
 Position: Vice-President, San Francisco
 Camerawork Board of Directors

**JOHN DIVOLA**, PLATE 1
*2800 Block, Western Avenue,*
*Los Angeles*, 1999, Color photograph,
30 $^1/_2$ x 92 in., Courtesy of the artist
 Born: Santa Monica, California, 1949
 Resides: Venice, California
 Highest Degree: M.F.A., University of
 California, Los Angeles, 1974
 Position: Professor, Art, University of
 California, Riverside

**ROD DRESSER**, PLATE 43
*Power Tower, Assemblage, Death Valley*
*National Monument, California, 1996,* 1996,
Gelatin silver print, 58 $^1/_2$ x 46 $^1/_2$ in.,
Courtesy of the artist
 Born: Watsonville, California, 1933
 Resides: Pebble Beach, California
 Highest Degree: B.S., United States Naval
 Academy, Annapolis, Maryland, 1956
 Monograph: *Artist's Choice: The*
 *Photographs of Rod Dresser*, Limited
 Editions Press, 2000

**JAMES FEE**, PLATE 36
*Weighing of Souls*, 1998, Manipulated gel-
atin silver print, 9 x 6 in., Courtesy of the
artist and Craig Krull Gallery, Santa Monica
 Born: Knoxville, Iowa, 1949
 Resides: Los Angeles, California
 Position: Instructor, Photography, Art
 Center College of Design,
 Pasadena, California

**ROBBERT FLICK**, PLATE 2
*Long Beach Harbor*, 1997-98, Ilfachrome
on Sintra board, 28 $^1/_4$ x 48 in., Courtesy
of the artist and Craig Krull Gallery, Santa
Monica
 Born: Amersfoort, Holland, 1939
 Resides: Claremont, California
 Highest Degree: M.F.A., University of
 California, Los Angeles, 1971
 Position: Professor of Art and Director of
 the Matrix Program, University of Southern
 California, School of Fine Arts,
 Los Angeles

**JACK FULTON**, PLATE 35
*Smokin' with the Devil*, 1998,
Photogram, gelatin silver print, cliché-
verre, 20 x 16 in., Courtesy of the artist
and Stremmel Gallery, Reno
 Born: San Francisco, California, 1939
 Resides: San Rafael, California
 Position: Professor, Photography,
 San Francisco Art Institute, California

**MAIZIE GILBERT**, PLATE 41
*Untitled #45*, 1999, Gelatin silver print,
16 x 20 in., Courtesy of the artist and
Patricia Sweetow Gallery, San Francisco
 Born: San Francisco, California, 1969
 Resides: San Francisco, California
 Highest Degree: M.F.A., Photography,
 California College of Arts and Crafts,
 Oakland, California, 1997
 Exhibition: *Pure: 5 California*
 *Photographers*, ESP, San Francisco,
 California, 2000

**JOEL AARON GLASSMAN**, PLATE 51
*Eurycantha horrida* from the series *Little Monsters*, 1998, Toned gelatin silver print, 20 x 96 in. total, Courtesy of the artist and Couturier Gallery, Los Angeles
Born: Bronx, New York, 1946
Resides: Los Angeles, California
Highest Degree: B.F.A., Sculpture, University of New Mexico, Albuquerque, 1967
Award: California Arts Council, Artist in Community Grant, 1992-5

**JIM GOLDBERG**, PLATE 63
*Untitled (Dad's Last Shave)*, 1993/2000, C-print, 8 x 10 in., Courtesy of the artist and Stephen Wirtz Gallery, San Francisco
Born: New Haven, Connecticut, 1953
Resides: San Francisco, California
Highest Degree: M.F.A., Photography, San Francisco Art Institute, California, 1979
Monograph: *Raised by Wolves*, Scallo, 1995

**KEN GONZALES-DAY**, PLATE 59
*Untitled #7 (Nepomuceno's Battle)*, 1996, C-print from digital negative, 27 x 38 in., Courtesy of the artist
Born: Santa Clara, California, 1964
Resides: Los Angeles, California
Highest Degree: M.F.A., Studio Art, University of California, Irvine, 1995
Position: Professor, Scripps, The Women's College of the Claremont Colleges, California

**TODD GRAY**, PLATE 65
*Untitled (Boy with dunce cap)*, 1996, Gelatin silver print, varnish, steel, 75 $^3/_4$ x 51 in., Courtesy of the artist and Shoshana Wayne Gallery, Santa Monica
Born: Los Angeles, California, 1954
Resides: Los Angeles, California
Highest Degree: M.F.A., California Institute of the Arts, Valencia, 1989
Award: City of Los Angeles Individual Artist Grant, 1997

**DOUG HALL**, PLATE 12
*Vatican Library, Main Reading Room*, 1996/97, Ektacolor print, 48 x 61 in., Courtesy of the artist and Rena Bransten Gallery, San Francisco
Born: San Francisco, California, 1944
Resides: San Francisco, California
Highest Degree: M.F.A., Sculpture, Rinehart School of Sculpture, The Maryland Institute of Art, Baltimore, Maryland, 1969
Position: Professor, New Genres Department, San Francisco Art Institute, California

**DEBORAH HAMMOND**, PLATE 57
*Regret III* from the series *Emotions*, 1998-99, Gelatin silver print, 20 x 16 in., Courtesy of the artist
Born: San Francisco, California, 1954
Resides: San Francisco, California
Project: Currently collaborating with Torben Eskerod, portrait photographer in Copenhagen

**KEVIN HANLEY**, PLATE 19
*Untitled*, 2000, 48 x 48 in., Courtesy of the artist and ACME., Los Angeles
Born: Sumter, South Carolina, 1969
Resides: Los Angeles, California
Highest Degree: M.F.A., Art Center College of Design, Pasadena, California
Solo Exhibition: Rocket Gallery, London, England, 2000

**TOM HAWKINS**, PLATE 17
*Obelisk at Salt Pans: Bonaire*, 1997, Platinum print, 4 x 4 in., Courtesy of the artist and Weston Gallery, Carmel
Born: Petersburg, Virginia, 1959
Resides: Modesto, California
Highest Degree: M.A., Landscape Architecture, University of Virginia, Charlottesville, 1992
Article: *Tom Hawkins*, B&W Magazine, Issue 2, 1999

**ANTHONY HERNANDEZ**, PLATE 38
*Waiting in Line #3*, 1996, Cibachrome print, 40 x 40 in., Courtesy of the artist and Grant Selwyn Fine Art, Beverly Hills
Born: Los Angeles, California, 1947
Resides: Los Angeles, California
Award: Rome Prize Fellowship; American Academy in Rome, Italy, 1998-99

**LYNN HERSHMAN**, PLATE 53
*Identity Cyborg*, 1999, Iris print, 30 x 30 in., Courtesy of the artist, Robert Koch Gallery, and Gallery Paule Anglim, San Francisco
Born: Cleveland, Ohio, 1941
Resides: San Francisco, California
Highest Degree: M.A., San Francisco State University, California, 1972
Position: Professor, Electronic Art, University of California, Davis

**TODD HIDO**, PLATE 10
*Untitled #2479-A*, 1999, C-print, 24 x 20 in., Courtesy of the artist and Stephen Wirtz Gallery, San Francisco
Born: Kent, Ohio, 1968
Resides: San Francisco, California
Highest Degree: M.F.A., California College of Arts and Crafts, Oakland, California, 1996
Award: Eureka Fellowship, Fleishhacker Foundation, 2001

**JOHN HUMBLE**, PLATE 4
*Monsoon Lagoon, Torrance*, 1992, Dye coupler photograph, 20 x 24 in., Courtesy of the artist and Jan Kesner Gallery, Los Angeles
Born: Washington, D.C., 1944
Resides: Santa Monica, California
Highest Degree: M.F.A., San Francisco Art Institute, California, 1973
Position: Professor, Fullerton College, California

**CLINT IMBODEN**, PLATE 58
*Personal Prisons #2*, 1993, Gelatin silver print, mixed media, 40 x 40 in., Courtesy of the San Francisco Museum of Modern Art Rental Gallery and Nika Gallery, San Francisco
 Born: St. Louis, Missouri, 1953
 Resides: Alameda, California
 Highest Degree: M.S., Kansas State University, Manhattan, Kansas, 1979
 Solo Exhibition: Centro Colombo Americano Galleria, Medellin, Colombia, 2000

**MICHAEL KENNA**, PLATE 16
*Ratcliffe Power Station, Study 36, Nottinghamshire, England, 1985/99*, Sepia toned gelatin silver print, 6 $^1/_2$ x 9 $^1/_4$ in., Courtesy of the artist and Stephen Wirtz Gallery, San Francisco
 Born: Widnes, Lancashire, England, 1953
 Resides: San Francisco, California
 Monograph: *A Twenty Year Retrospective*, Treville, 1994

**DALE KISTEMAKER**, PLATE 44
*Track #2*, 1999, Gelatin silver print, 40 x 96 in. total, Courtesy of the artist and Robert Koch Gallery, San Francisco
 Born: Cleveland, Ohio, 1948
 Resides: San Francisco, California
 Highest Degree: M.A., San Francisco State University, California, 1975
 Position: Professor of Art, San Francisco State University, California

**ROBIN LASSER**, in collaboration with Kathryn Sylva, PLATE 29
*Fear of Fat Eats Us Alive*, Billboard, Inkjet on vinyl, February-April, 2000, Bryant & Fourth Streets, San Francisco, 168 x 576 in., Courtesy of the artist
 Born: Buffalo, New York, 1956
 Resides: Oakland, California
 Highest Degree: M.F.A., Photography, Mills College, Oakland, California, 1988
 Position: Associate Professor and Coordinator of Photography Area, San Jose State University, California

**DINH Q. LE**, PLATE 55
*Untitled #15 (Cambodia: Splendour and Darkness)*, 1999, C-print and linen tape, 20 x 86 $^1/_4$ in. total, Private collection, Courtesy of Shoshana Wayne Gallery, Santa Monica
 Born: Vietnam, 1968
 Resides: Moorpark, California
 Highest Degree: M.F.A., Photography, School of Visual Arts, New York, New York, 1992
 Award: National Endowment for the Arts Fellowship, Photography, 1994-95

**MICHAEL LEWIS**, PLATE 22
*Untitled*, 1997, C-print, 20 x 20 in., Courtesy of the artist
 Born: Pennsylvania, 1970
 Resides: Los Angeles, California
 Highest Degree: M.F.A., Photography, San Francisco Art Institute, California, 1996

**SHARON LOCKHART**, PLATE 24
*Untitled*, 1996, C-print, 41 x 32 in., Courtesy of Daniel and Jeanne Fauci, Los Angeles
 Born: Norwood, Massachusetts, 1964
 Resides: Los Angeles, California
 Highest Degree: M.F.A., Art Center College of Design, Pasadena, California
 Catalog and Traveling Exhibition: *Sharon Lockhart*, Museum Boijmans van Beuningen, Rotterdam, 1999-2000

**LAURIE LONG**, PLATE 28
*Airplane SOS* from the series *Becoming Nancy Drew*, c. 1996, C-print, Linotronic caption, 28 x 32 in. total, Courtesy of the artist
 Born: Castro Valley, California, 1960
 Resides: San Francisco, California
 Highest Degree: M.F.A., Photography, San Francisco State University, California, 1996
 Solo Exhibition: *Dating Surveillance Project*, University of California, Riverside/California Museum of Photography, 1999

**DANIEL JOSEPH MARTINEZ**, PLATE 56
*technosocial habitat, simulation #.0605.8759* from the *Tactics of disappearance and transmutation* series, 1998-99, Color duratrans prints, 36 x 96 in. total, Courtesy of the artist
 Born: Los Angeles, California, 1957
 Resides: Los Angeles, California
 Highest Degree: B.F.A., California Institute of the Arts, Valencia, 1979
 Monograph: *The Things You See When You Don't Have a Grenade!*, Smart Art Press, 1996

**ROGER MINICK**, PLATE 6
*Face of Crazy Horse*, 1999 from the series *Holga*, 1999, Gelatin silver print, 14 x 14 in., Courtesy of the artist and Jan Kesner Gallery, Los Angeles
 Born: Ramona, Oklahoma, 1944
 Resides: Danville, California
 Highest Degree: M.F.A., Studio Art, University of California, Davis, 1986
 Position: Instructor, Photography, Academy of Art College, San Francisco, California

**RICHARD MISRACH**, PLATE 7
*Swamp and Pipeline, Geismar, Louisiana*
from the series *Cancer Alley*, 1998/99,
C-print, 40 x 50 in., Commissioned by the
High Museum of Art, Atlanta, Georgia,
Courtesy of the artist and Fraenkel
Gallery, San Francisco
> Born: Los Angeles, California, 1949
> Resides: Berkeley, California
> Highest Degree: B.A., Psychology,
> University of California, Berkeley, 1971
> Monograph: *Cantos del Desierto*,
> Diputación de Granada, Spain, 1999

**HAN NGUYEN**, PLATE 37
*Brancusi's Bird*, 1992, Gelatin silver print,
4 x 3 $\frac{1}{8}$ in., Courtesy of the artist and
Stephen Cohen Gallery, Los Angeles
> Born: Vietnam, 1956
> Resides: San Diego, California

**KELLY NIPPER**, PLATE 25
*Movement with chalk*, 1998, C-print, 48 x 62
in., Courtesy of Shoshana and Wayne Blank
> Born: Edina, Minnesota, 1971
> Resides: Los Angeles, California
> Highest Degree: M.F.A., Photography,
> California Institute of the Arts,
> Valencia, 1995
> Exhibition: *Guarene Arte 2000*, Palazzo
> Re Rebaudengo, Guarene d'Alba,
> Torino, Italy

**ABNER NOLAN**, PLATE 54
*Untitled* from the series *Notation*, Detail,
1999, Color photograph, 30 x 40 in.,
Courtesy of the artist
> Born: Syracuse, New York, 1972
> Resides: San Francisco, California
> Highest Degree: M.F.A., Photography,
> California College of Arts and Crafts,
> Oakland, California, 1998
> Position: Instructor, Photography,
> University of California, Berkeley, and
> California College of Arts and Crafts,
> Oakland, California

**CATHERINE OPIE**, PLATE 26
*Tammy Rae & Kaia, Durham, North
Carolina*, 1998, C-print, 40 x 50 in.,
Courtesy of the artist and Regen Projects,
Los Angeles
> Born: Sandusky, Ohio, 1961
> Resides: Los Angeles, California
> Highest Degree: M.F.A., California
> Institute of the Arts, Valencia, 1988
> Position: Professor, Photography, Yale
> University, New Haven, Connecticut

**GAY OUTLAW**, PLATE 45
*Light Fixture #3 - "Eclipse,"* 1991-92,
Gelatin silver print, 22 x 20 in., Courtesy
of the artist and refusalon, San Francisco
> Born: Mobile, Alabama, 1959
> Resides: San Francisco, California
> Highest Degree: B.A., French, University
> of Virginia, Charlottesville, 1981
> Award: SECA Award, San Francisco
> Museum of Modern Art, California, 1998-9

**RONDAL PARTRIDGE**, PLATE 47
*Preston Patent, 1997*, 1997 Platinum pal-
ladium, 5 x 7 $\frac{1}{2}$ in., Courtesy of the artist
> Born: San Francisco, California, 1917
> Resides: Berkeley, California
> Exhibition: *Family of Man*, Museum of
> Modern Art, New York, New York, 1955

**NIGEL POOR**, PLATE 48
*June 1998* from the series *Found*, Detail,
1998, Toned gelatin silver print,
11 x 9 in., Courtesy of the artist and
Haines Gallery, San Francisco
> Born: Boston, Massachusetts, 1963
> Resides: San Francisco, California
> Highest Degree: M.F.A., Photography,
> Massachusetts College of Art,
> Boston, 1992
> Solo Exhibition: *Found*, Haines Gallery,
> San Francisco, California, 2000

**J. JOHN PRIOLA**, PLATE 40
*Switch*, 1999, Gelatin silver print,
40 x 32 in., Courtesy of the artist and
Fraenkel Gallery, San Francisco
> Born: Denver, Colorado, 1960
> Resides: San Francisco, California
> Highest Degree: M.F.A., Photography, San
> Francisco Art Institute, California, 1987
> Monograph: *Once Removed, Portraits
> by J. John Priola*, Arena Editions, 1998

**PHILIPP SCHOLZ RITTERMANN**, PLATE 8
*Hoover Dam*, Detail, 1999, Inkjet digital
print, 18 x 35 in. total, Courtesy of the artist
> Born: Lima, Peru, 1955
> Resides: San Diego, California
> Solo Exhibition: *Philipp Scholz
> Rittermann: Translating The View*,
> Museum of Photographic Art,
> San Diego, California, 2001

**RICHARD ROSS**, PLATE 13
*Tally Pagoda, Bagan, Myanmar*, 1990,
C-print, 48 x 48 in., Courtesy of the artist
> Born: Brooklyn, New York, 1947
> Resides: Santa Barbara, California
> Highest Degree: M.F.A., University of
> Florida, Gainesville, 1973
> Monograph: *Gathering Light*, University
> of New Mexico Press, 2000

**LIZA RYAN**, PLATE 21
*Displacement 2*, 1999, C-print,
4 $\frac{3}{4}$ x 11 $\frac{1}{2}$ in., Courtesy of the artist and
Griffin Contemporary, Venice, California
> Born: Norfolk, Virginia, 1965
> Resides: Venice, California
> Highest Degree: M.F.A., California State
> University, Fullerton, 1994
> Monograph: *Liza Ryan*, William Griffin
> Editions and Manfred Heiting, 2000

**ROCKY SCHENCK,** PLATE 64
*Dresden*, 1995, Gelatin silver print,
17 $^1/_4$ x 23 $^5/_8$ in., Courtesy of the artist
and Paul Kopeikin Gallery, Los Angeles
  Born: Dripping Springs, Texas
  Resides: Hollywood, California
  Solo Exhibition: *Solitude*, Paul Kopeikin
  Gallery, Los Angeles, California, 2000

**SUSAN SCHWARTZENBERG,** PLATE 30
*The Homefront (Prototype Image Ladder)*
from the *Rosie the Riveter Memorial*,
Detail, 2000, Iris print, 12 x 18 in.,
Courtesy of the artist
  Born: Chicago, Illinois, 1951
  Resides: San Francisco, California
  Project: Public Art Project in collaboration
  with Cheryl Barton, Rosie the Riveter
  Memorial, Richmond, California, 2000

**SUSAN SILTON,** PLATE 39
*Fig. 6* from the series *Aviate*, 1998,
Ektacolor print, 35 $^3/_8$ x 40 $^7/_8$ in.,
Courtesy of the artist
  Born: Los Angeles, California, 1956
  Resides: Los Angeles, California
  Highest Degree: B.A., University of
  California, Los Angeles, 1978
  Award: James D. Phelan Art Award in
  Photography, San Francisco
  Foundation/San Francisco
  Camerawork, California, 1995

**CAMILLE SOLYAGUA,** PLATE 49
*Salle de Pièces Molles #27*, 1998, Gelatin
silver print, 20 x 16 in., Courtesy of the
artist and Shapiro Gallery, San Francisco
  Born: Denver, Colorado, 1959
  Resides: San Francisco, California
  Highest Degree: M.A., Spanish
  Literature, Middlebury College,
  Vermont, 1985
  Monograph: *Benevolent Pleasures of
  Sight*, Nazraeli Press, 1997

**DON SUGGS,** PLATE 34
*Pacifier VII*, 1998, Gelatin silver print,
9 $^1/_8$ x 7 $^3/_4$ in., Courtesy of the artist and
L.A. Louver Gallery, Los Angeles
  Born: Fort Worth, Texas, 1945
  Resides: Los Angeles, California
  Highest Degree: M.F.A., University of
  California, Los Angeles, 1972
  Position: Instructor, Art, University of
  California, Los Angeles

**LARRY SULTAN,** PLATE 27
*Tasha's Third Film*, 1998-99, C-print,
30 x 40 in., Courtesy of the artist and
Stephen Wirtz Gallery, San Francisco
  Born: New York, 1946
  Resides: Greenbrae, California
  Highest Degree: M.F.A., Photography,
  San Francisco Art Institute,
  California, 1973
  Monograph: *Pictures From Home*,
  Harry N. Abrams, 1992

**STEPHANIE SYJUCO,** PLATE 52
*Paradise Island*, 1998, Digitally manipu-
lated Cibachrome print, 32 x 40 in.,
Courtesy of the artist and Haines Gallery,
San Francisco
  Born: Manila, Philippines, 1974
  Resides: San Francisco, California
  Highest Degree: B.F.A., San Francisco
  Art Institute, California, 1995
  Award: Eureka Foundation Fellowship,
  2001

**ARTHUR TRESS,** PLATE 31
*Getting Hooked, Act 3* from the series
*Death of a Salaryman, A Life in Nine Acts*,
1995, Cibachrome print, 15 x 15 in.,
Courtesy of the artist
  Born: New York, 1940
  Resides: Cambria, California
  Monograph and Traveling
  Retrospective: *Fantastic Voyage: Four
  Decades of Photography*, The Corcoran
  Gallery of Art, Washington, D.C., 2001

**CATHERINE WAGNER,** PLATE 42
*Double Heart Cross-Section*, 1998, Iris
print, 31 $^1/_4$ x 44 $^1/_4$ in., Courtesy of the
artist and Fraenkel Gallery, San Francisco
  Born: San Francisco, California, 1953
  Resides: San Francisco, California
  Highest Degree: M.A., San Francisco
  State University, California, 1977
  Award: John Simon Guggenheim
  Memorial Foundation Fellowship, 1987

**HENRY WESSEL,** PLATE 11
*Los Angeles No. 23* from the series *Night
Walk*, 1995, Gelatin silver print, 24 x 20 in.,
Courtesy of the artist and Rena Bransten
Gallery, San Francisco
  Born: Teaneck, New Jersey, 1942
  Resides: Point Richmond, California
  Highest Degree: M.F.A., Visual Studies
  Workshop, State University of New
  York, Buffalo, 1972
  Monograph: *Henry Wessel*, Rena
  Bransten Gallery, San Francisco,
  California, 2000

**JO WHALEY,** PLATE 50
*Luna Light*, 1999, C-print, 24 x 20 in.,
Courtesy of the artist and Robert Koch
Gallery, San Francisco
  Born: Sacramento, California, 1953
  Resides: Oakland, California
  Highest Degree: M.F.A., Art, University
  of California, Berkeley, 1979
  Solo Exhibition: San Jose Museum of
  Art, California, 2000

**KELLI YON,** PLATE 60
*Emetic Stillness*, Detail, 1998, C-prints,
40 x 48 in. total, Courtesy of the artist
and Haines Gallery, San Francisco
  Born: Concord, California, 1967
  Resides: San Francisco, California
  Highest Degree: M.F.A., Photography,
  California College of Arts and Crafts,
  Oakland, California, 1997
  Position: Visiting Lecturer, Photography,
  California College of Arts and Crafts,
  Oakland, California